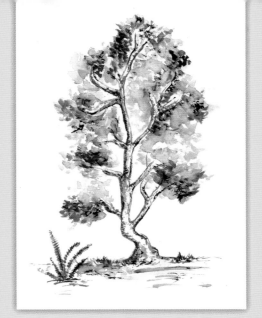

BEGINNING CHINESE BRUSH

Chinese brushwork is an ancient art form that developed hundreds of years ago in China and is now very popular with artists all over the world. It captures the essence of nature and expresses the feelings of the artist. The animal and flower subjects symbolize good fortune, good luck, wisdom, renewal, purity, and more. In Chinese brush painting, each brushstroke has its own spirit and moves in that moment; it cannot be improved or corrected. Rather than sketch or outline, the artist holds the subject in mind and transforms that image into reality using quick and instinctive strokes. To the artist, the whole painting becomes part of the subject itself and, therefore, part of nature. —*Monika Cilmi*

CONTENTS

TOOLS & MATERIALS

The materials used for Chinese brush painting are called the Four Treasures: brush, paper, ink, and ink stone.

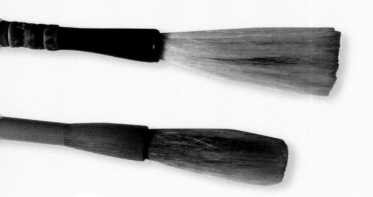

BRUSHES

Chinese brushes are made of animal hair glued into a bamboo handle. New brushes are stiffened to protect the fibers.

Brushes contain either a single type of hair or a mixture of two or three hair types. Goat-hair brushes are very common and easy to find. Goat-, squirrel-, and rabbit-hair brushes are used for soft strokes (in paintings of animals, flowers, and fruit), and brushes made of wolf, badger, and horse hair are common for landscape work.

TIP Before using your brushes for the first time, soak them in water. Once dry, store them upside down on a Chinese brush holder (available in different shapes and styles) or in a normal pen or brush holder.

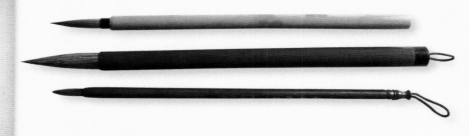

PAPER

The most common Chinese paper used for Chinese brush painting is Xuan. Known in Western countries as rice paper, it is very absorbent and strong. Other papers, such as grass paper and mulberry paper, are available in sheets and rolls. As a beginner, try painting on different types to learn their absorbency and general quality.

INK

Ink comes in stick and liquid form. An ink stick is made from charcoal or charcoal soot mixed with glues and oils. Ink sticks can be decorated, and the older the ink stick, the better the ink quality. Good-quality ink produces smooth and even tones. Although liquid ink is less expensive, it does not give the same tonality control as the ground stick ink.

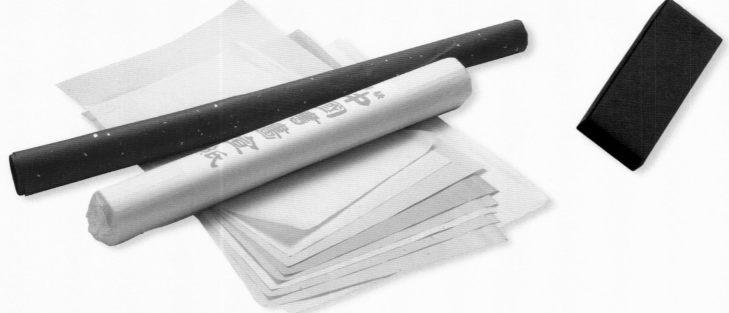

INK STONE

Use the ink stone, which is made from carved stone or slate, to grind the ink stick. Ink stones come in different shapes, and the best is the Duan from South China. It is a good idea to start with a traditional rectangular or round stone (which is less expensive) to learn how to grind the ink. Find ink stones in various online shops.

When it comes to ink stones, quality is important. A rough stone will not produce good ink.

COLORS, SEALS, AND OTHER USEFUL TOOLS

Western watercolors work well, but it is preferable to use Chinese or Japanese paints made specifically for this style. They are available in different forms: granules, powders, and liquids.

Seals form an integral part of the painting. They are carved in stone and printed using cinnabar paste. Artists can sign their paintings with their name seal.

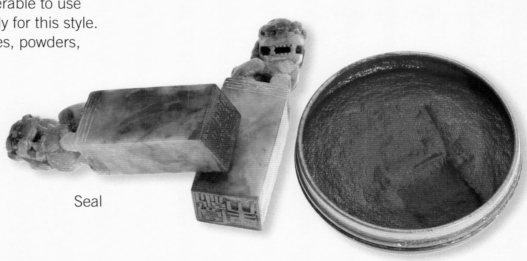

Seal

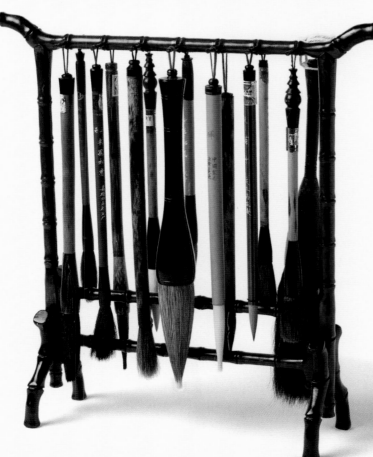

Other useful materials include:
- a brush stand for resting brushes and keeping your station clean
- a brush holder to let brushes dry
- paperweights to keep the paper in place; simple pebbles can be used or traditional Chinese or Japanese decorated bars
- small plates or a palette for the colors
- a small water dropper
- felt to use under the paper

GETTING STARTED

When practicing Chinese brush techniques, preparation is vital. It guides your spirit and your body to the experience of painting and connecting with nature. There are two main styles: freestyle (*xieyi*, literally "writing ideas"), which relies on simplicity, and meticulous (*gongbi*, "detailed strokes"), which is more precise.

PREPARE YOUR WORK SPACE

If working on a table, clear away unneeded items and keep all painting materials and tools on one side and the paper in front of you. Cover the table with newspaper or position felt under the paper. Then check that you have all the brushes needed, a brush stand, a water dropper, ink sticks, and an ink stone.

TIP *Practicing Chinese brush painting on the floor is a great experience but only if you're freestyle painting on very large paper.*

GRIND THE INK

Preparing the ink is a crucial part of the preparation. By repeating the circular movement, you can focus on the work you are about to create without external distractions.

Take the ink stick in your hand, add a small amount of water to the flat surface of the ink stone, and then holding the stick upright, move it gently in continuous clockwise movements. You will see how the ink changes. It may take a while to get a vibrant black color, so keep a sketch pad or spare paper nearby to test the ink before starting to paint.

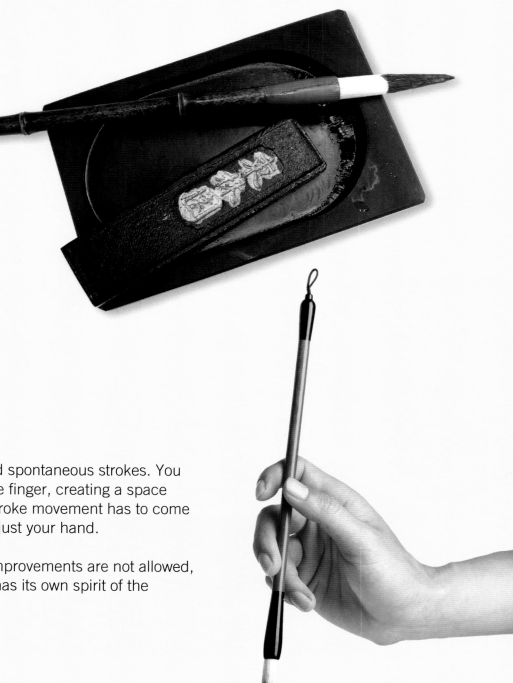

HOLDING THE BRUSH

Learn how to hold a Chinese brush to create fluid and spontaneous strokes. You need to hold it between the thumb, index, and middle finger, creating a space between your fingers and palm. Because the brushstroke movement has to come from the shoulder, move your whole arm rather than just your hand.

Remember that in Chinese tradition, corrections or improvements are not allowed, so paint with confidence and precision. Each stroke has its own spirit of the moment, and it cannot be repeated.

BASIC STROKES

When loading the brush with ink, try not to twist the brush. Twisting causes the natural fiber to open out, making the brush harder to control. Wipe excess ink off the brush using the edge of the ink stone.

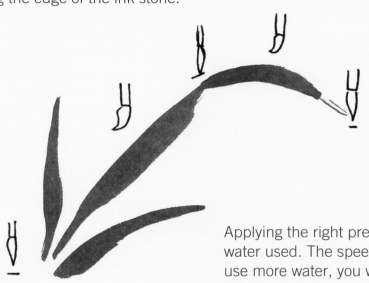

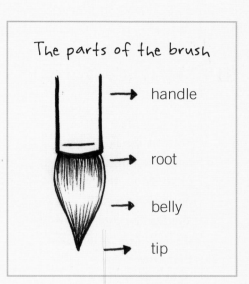

The parts of the brush

handle

root

belly

tip

To draw a fine line, use the tip of the brush. For a wide stroke, use the side of the brush.

Applying the right pressure on the brush determines the speed and amount of water used. The speed defines the stroke and its strength and personality. If you use more water, you will have smoother brushstrokes. Less water results in dry, rough effects. Practice variation in tone by diluting the ink.

My approach to this form of art is often experimental. If you want to try something different or just test an effect, use a pastry brush instead of a conventional Chinese brush to create splashing or very rough effects. These can work well on subjects such as rocks.

Try practicing various small strokes to create texture. They can be used for effects on all subjects.

Create tree bark by using very wet strokes, and then adding dry ink on top while still wet to blend in the strokes to give it texture and realism.

SHAPE & CONTOUR

The graceful nature and flowing movement of cats make felines the perfect subject for learning Chinese brush painting. Using black ink, practice making smooth brushstrokes to capture the elegant shape.

Prepare your workstation and start grinding some ink using an ink stick and ink stone. Add water, and make sure you have nice, clear black ink.

SITTING CAT

To start the body, draw a long line down, using less pressure at the end so a pointed tip results. Draw a shorter line that curves to the left. Add a third line that curves down on the right side of the cat.

Load a medium brush, and using just the tip of your brush, draw two pointed ears. Add a short line between them.

Add the shape of the face with a short round stroke on the left and another on the right as a continuation of the right ear.

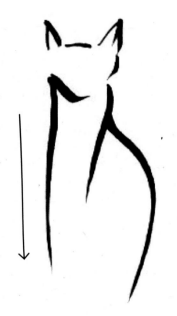

Starting the brush at the end of the previous stroke, create a thicker line moving toward the left to create the tail. Remember to use more pressure in the middle of the stroke and then release the brush to create a slightly pointed end.

Now that the form is complete, add details, such as thin lines for the legs, eyes, and whiskers.

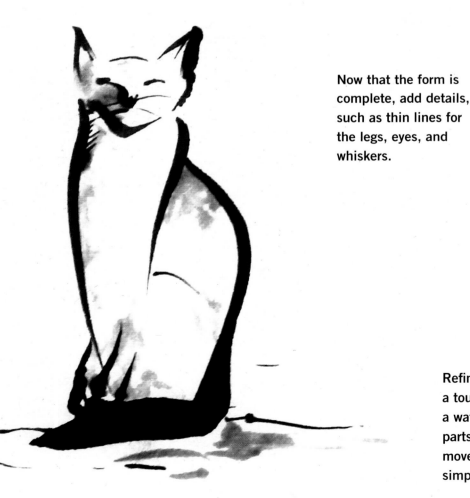

Refine the painting with a touch of shading, using a watery brush on some parts with free and uneven movements. Then add some simple lines for the ground.

CAT LYING DOWN

Load a medium brush and draw two pointed ears, leaving space between them. Add a short line between the ears. Try to use just the tip of your brush.

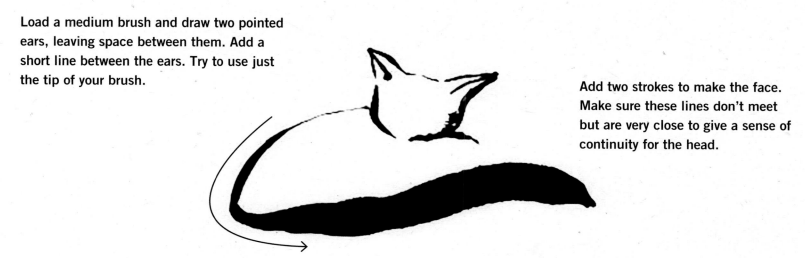

Add two strokes to make the face. Make sure these lines don't meet but are very close to give a sense of continuity for the head.

Paint a longer, round line starting at the left side of the head. Apply more pressure, up to half of the brush's hair, to achieve the effect of a thick tail. The movement has to be quick. The paintbrush should contain a lot of ink but not too much.

Once you have painted the tail, complete the body by adding legs with a round stroke for the folded leg and a long straight stroke with a small turn at the end for the front lying one.

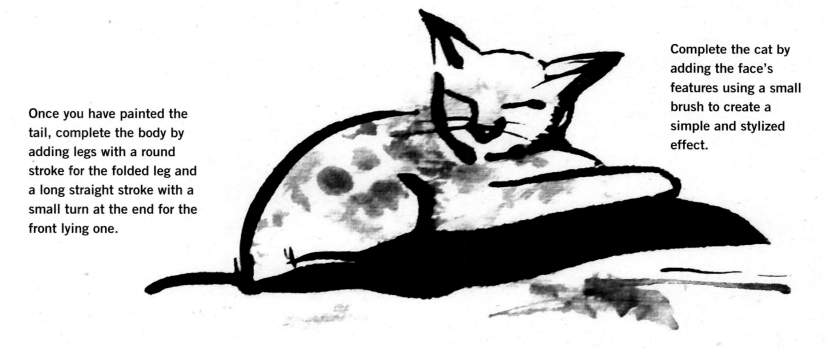

Complete the cat by adding the face's features using a small brush to create a simple and stylized effect.

Add some character by using more black to create some shade and grey tones using a watery brush.

ADDING COLOR

One of the most prevalent symbols in Chinese culture, the fish symbolizes wealth, harmony, marital happiness, and fertility. In this project, we'll see two versions of this subject: one painted in black, the other in vibrant orange-red.

SWIMMING FISH

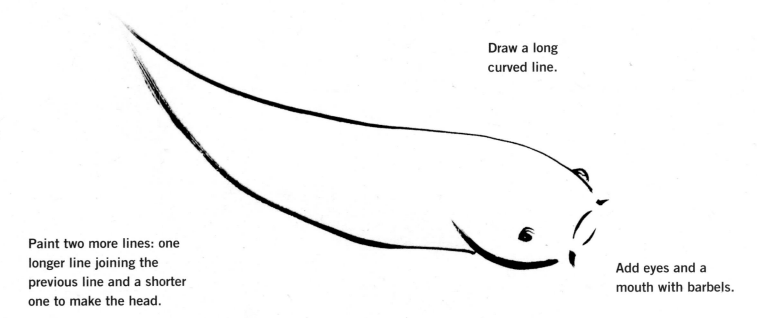

Draw a long curved line.

Paint two more lines: one longer line joining the previous line and a shorter one to make the head.

Add eyes and a mouth with barbels.

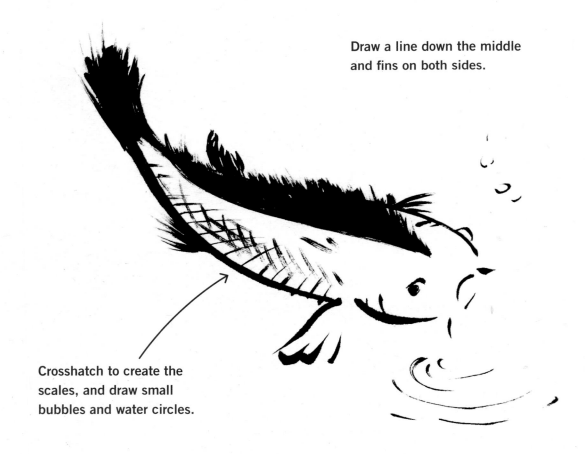

Draw a line down the middle and fins on both sides.

Add a fin with long, overlapping strokes.

Crosshatch to create the scales, and draw small bubbles and water circles.

JUMPING FISH

Using the tip of a small or medium brush, paint a long, thin, curved line. Do the same on the left with a curved stroke, leaving a gap where the mouth will be.

To create the tail fin, draw a few overlapping long and thin lines, and add two small and very short strokes on the side of the face to make barbels.

Paint more small fins on both sides and add details.

Now add color on the body using a brush filled with watery ink. Paint crosshatched lines to give the effect of scales, leaving some white areas.

Draw a long line down the middle following the curve of the body. Use a small brush to add some quick strokes on top of this line. Add the eyes.

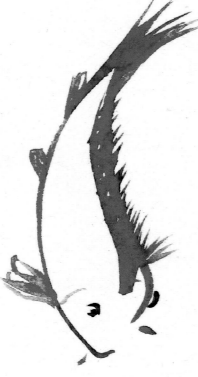

With light blue ink, create a splash of water using circular but imprecise strokes to look rough and natural.

PRACTICING BRUSHSTROKES

Quick brushstrokes capture the essence of this beautiful blue bird perched on a branch. Practice releasing pressure to create tapered lines and using the different parts of the brush to create triangles and other shapes.

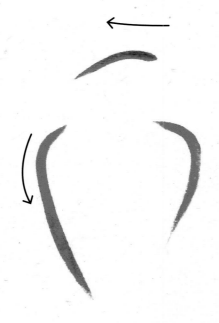

Load the brush with blue ink and hold it upright. Create the first stroke moving from right to left, and release the brush slowly at the end to create a tapered point with the brush tip.

Use the same amount of pressure when painting the next two strokes, this time moving from top to bottom.

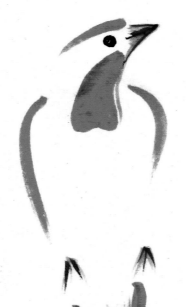

Use a small brush to create the bill and legs in a different color. Use just three small strokes for both.

Now add the shape on the bird's breast creating an outline first and then filling with color. Add a small eye on top.

To create the tail, draw two curvy strokes nearly meeting in the middle. Fill the space in between with thin strokes to resemble feathers.

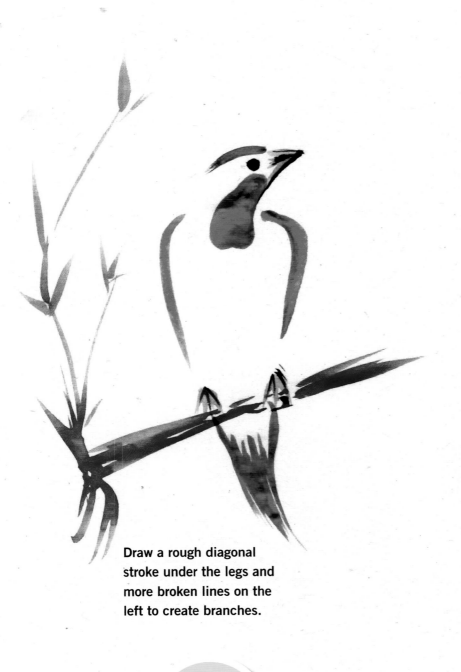

Draw a rough diagonal stroke under the legs and more broken lines on the left to create branches.

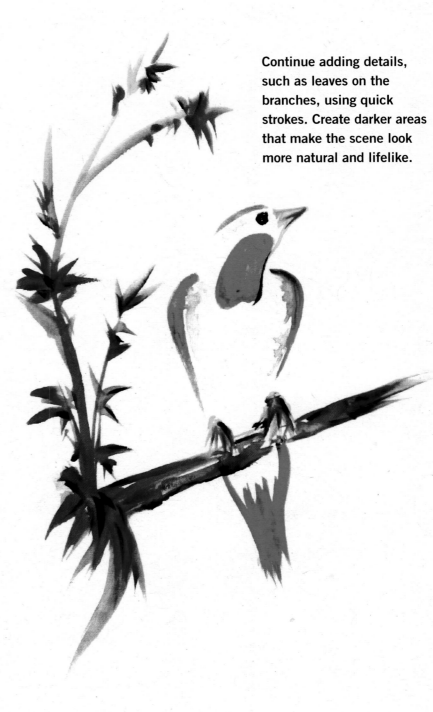

Continue adding details, such as leaves on the branches, using quick strokes. Create darker areas that make the scene look more natural and lifelike.

TIP

The best way to paint a triangular shape is to press the body of the brush on the paper and then release it quickly.

PLAYING WITH HUES

Using just a few colors, you can create a range of hues by diluting ink with water. With its numerous petals, the chrysanthemum gives you the perfect opportunity to play with colors. Experiment with the tones you choose to create a stunning mosaic.

Load the brush with paint and hold it upright. Paint six flower petals, three on the left side and three on the right side. Start with the top left petal, followed by the top right petal, move to the middle left petal, and so on.

Dilute the paint, load another brush with the lighter paint, and add the lighter strokes behind the main strokes.

Add two longer strokes below the bottom petals.

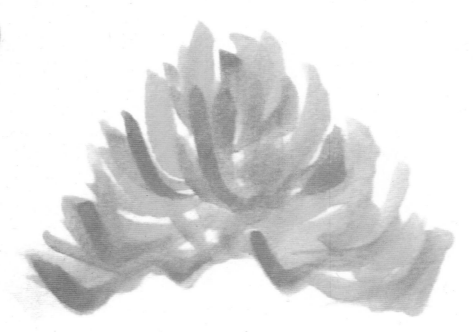

Keep adding strokes, filling the blank spaces and overlapping various colors, from pale yellow to deep orange.

TIP

Make sure the petals form a triangular (not round) flower.

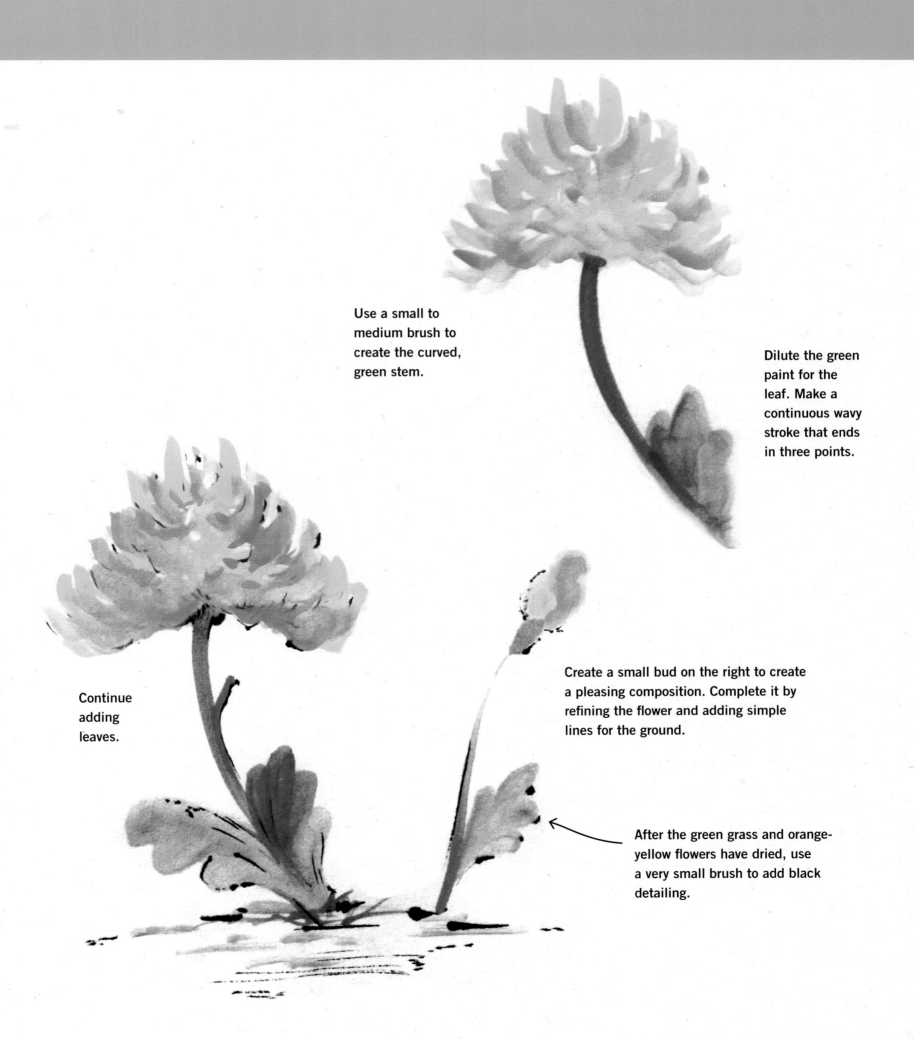

Use a small to medium brush to create the curved, green stem.

Dilute the green paint for the leaf. Make a continuous wavy stroke that ends in three points.

Continue adding leaves.

Create a small bud on the right to create a pleasing composition. Complete it by refining the flower and adding simple lines for the ground.

After the green grass and orange-yellow flowers have dried, use a very small brush to add black detailing.

CAPTURING PATTERNS

Do you love spotting patterns in nature? Whether it's the whorl of a seashell, the rings of a tree stump, or the spots on a butterfly's wings, these patterns are a great way to practice and play with Chinese brush painting.

For the top of the second wing, start where the first wing begins, drawing a similar triangular shape.

Load the brush with black ink and hold it upright. Paint the top of the first butterfly wing by swooping upward and to the left, then down.

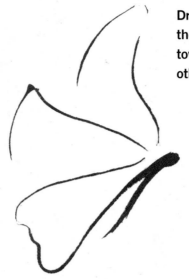

Draw a third continuous stroke, starting where the other strokes begin. Move the line down toward the right and up again to join the others lines in the middle.

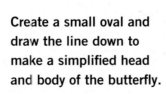

Create a small oval and draw the line down to make a simplified head and body of the butterfly.

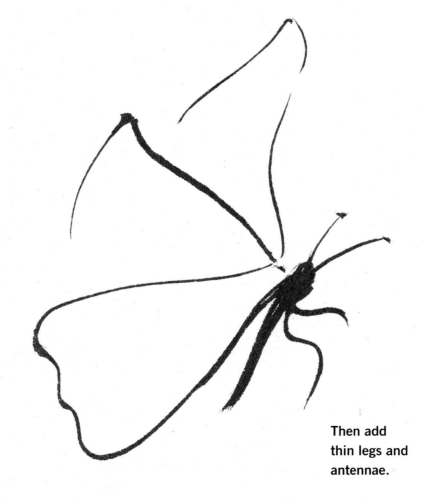

Then add thin legs and antennae.

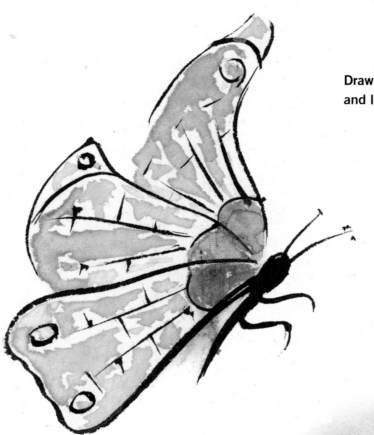

Draw details, such as patterns, dots, and lines, on the butterfly's wings.

When the painting is nearly dry, add colors to the butterfly wings. Try yellow and blue, blending the two colors in some areas and leaving some areas untouched. Refine the painting in certain areas with a darker, more vibrant color such as red.

To complete the composition, create a simple background with light pastel colors.

CREATING A COMPOSITION

Widen your perspective and create a composition with animals and plants. In this scene, explore scale, perspective, and the interplay between flora and fauna.

Load a medium brush with watery red ink, and start painting the bird's main body from head to wings. Leave some space in the middle of the body blank so that you can add a bit of yellow. Let dry.

Add some black on top of the bill and body, to the eye, and a bit on the branch as well.

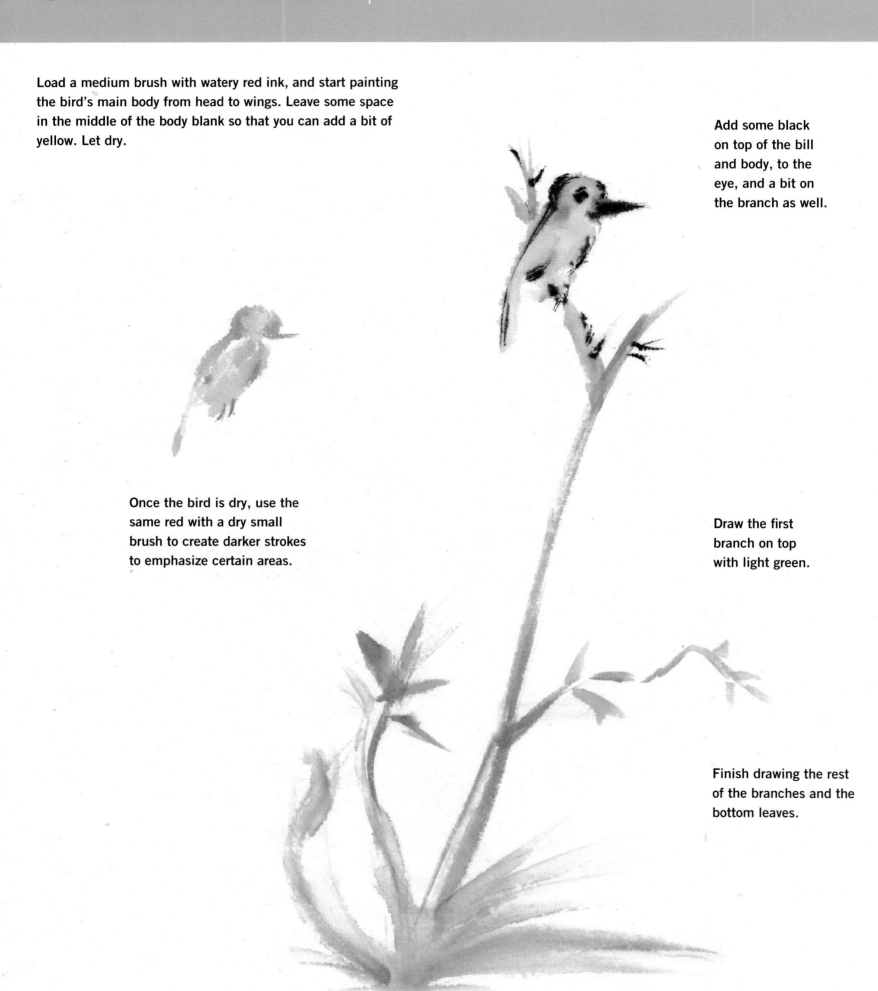

Once the bird is dry, use the same red with a dry small brush to create darker strokes to emphasize certain areas.

Draw the first branch on top with light green.

Finish drawing the rest of the branches and the bottom leaves.

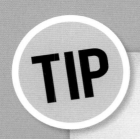

TIP

Try drawing a second bird perching on a lower branch to add balance and interest to your painting.

Add more thin branches on top, and draw stylized flowers with a darker red using quick strokes.

Finish off your painting with sparse and very watery yellow and blue in the background.

Refine the lines with leaves, and add some brown and black in some sections.

Add details to the ground, such as more brown (with short interrupted strokes for the soil) and a rock.

BUILDING TEXTURE

By using a variety of brushstrokes—short and choppy, round and smooth—you can create a variety of textures and effects, each lending to the spirit of the subject. In this painting, a tea hut stands in the background as watery stepping stones extend into the foreground.

Use a medium brush with brown or gray to draw the top of the hut. Rather than thick strokes, use parallel, thin strokes.

Continue to build the tea hut, adding a window with rough strokes.

Start painting the base for the ground with watery brush.

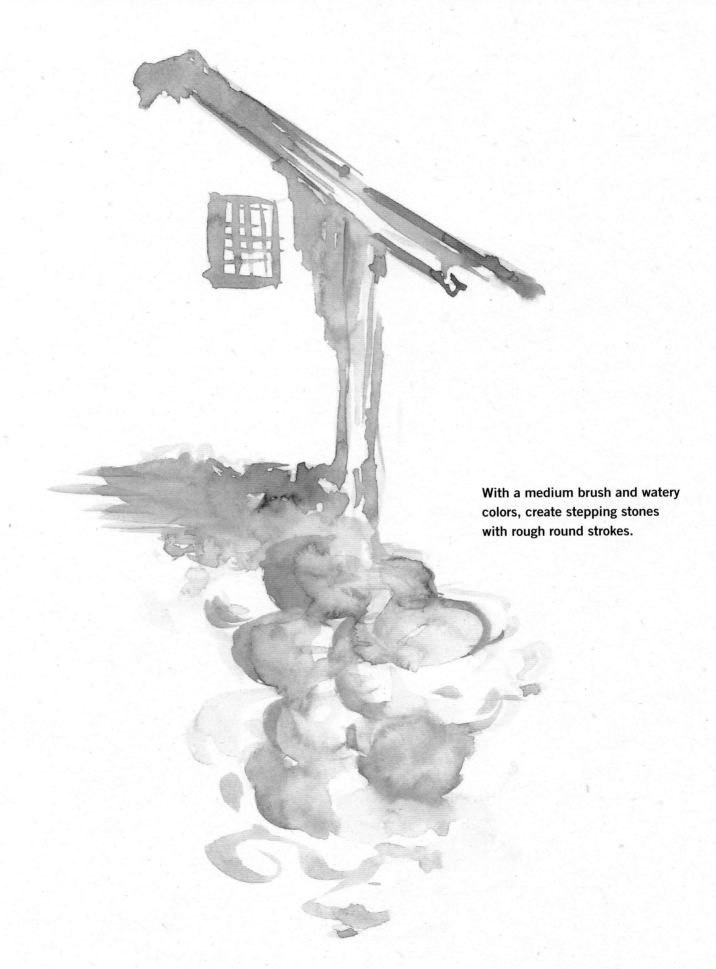

With a medium brush and watery colors, create stepping stones with rough round strokes.

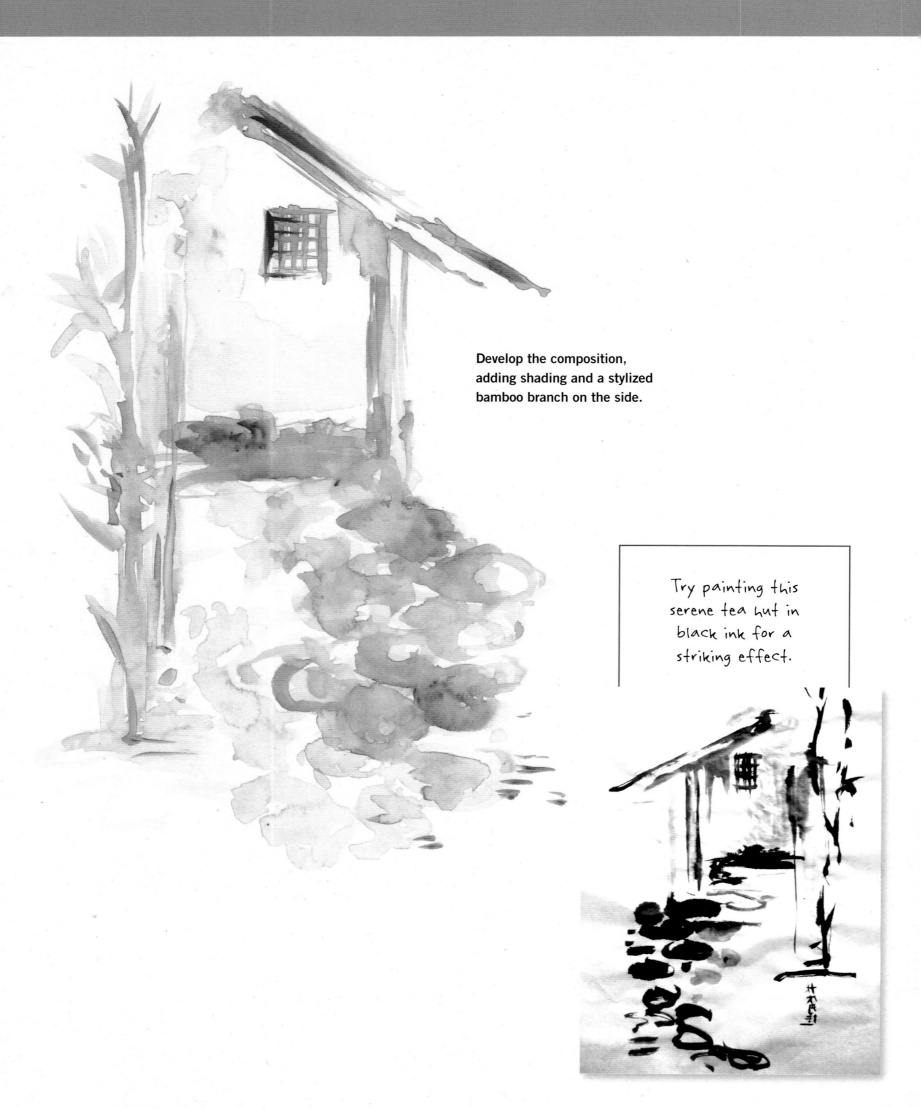

Develop the composition, adding shading and a stylized bamboo branch on the side.

Try painting this serene tea hut in black ink for a striking effect.

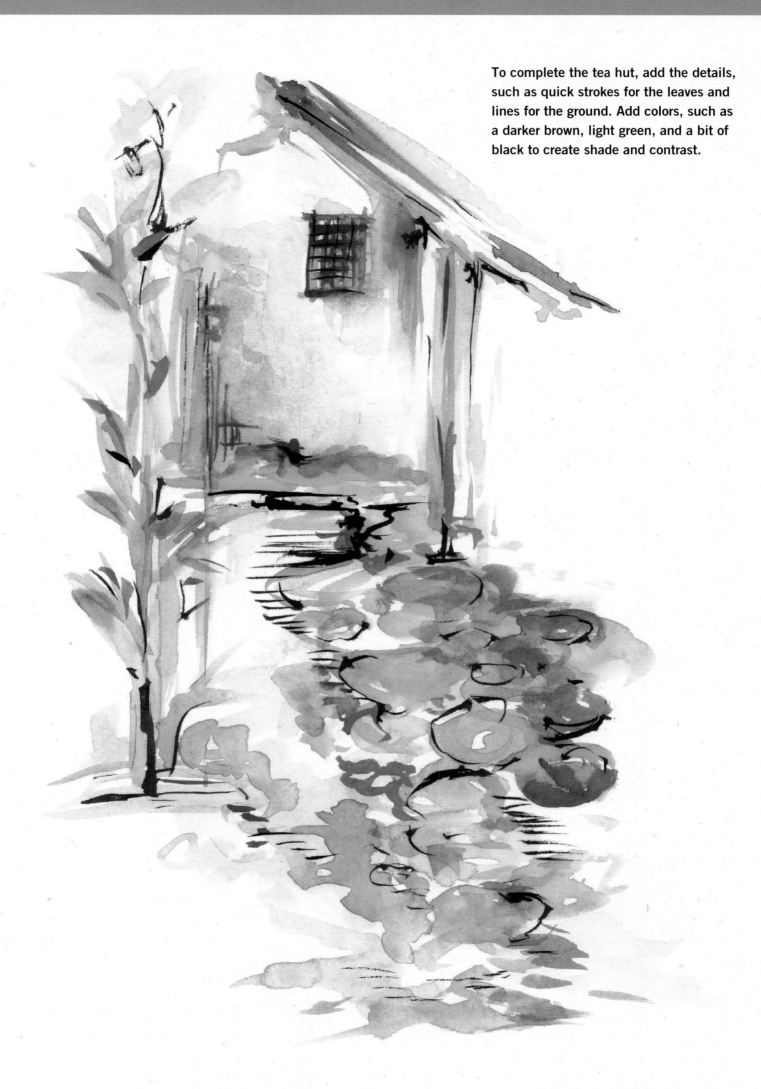

To complete the tea hut, add the details, such as quick strokes for the leaves and lines for the ground. Add colors, such as a darker brown, light green, and a bit of black to create shade and contrast.

RENDERING FOLIAGE

This tall, delicate tree presents the perfect opportunity to work on building your lifelike painting from the ground up. The tree trunk and branches encourage free and irregular brushstrokes.

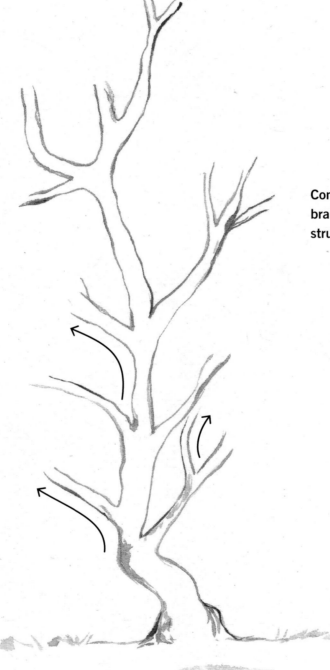

Continue to add more branches to complete the structure of the tree.

Using a small brush loaded with light brown ink, start drawing the outline of the tree trunk and branches from the bottom up. Keep your brushstrokes wavy and irregular.

Remember: Never correct or edit your painting. If something goes wrong, just start again.

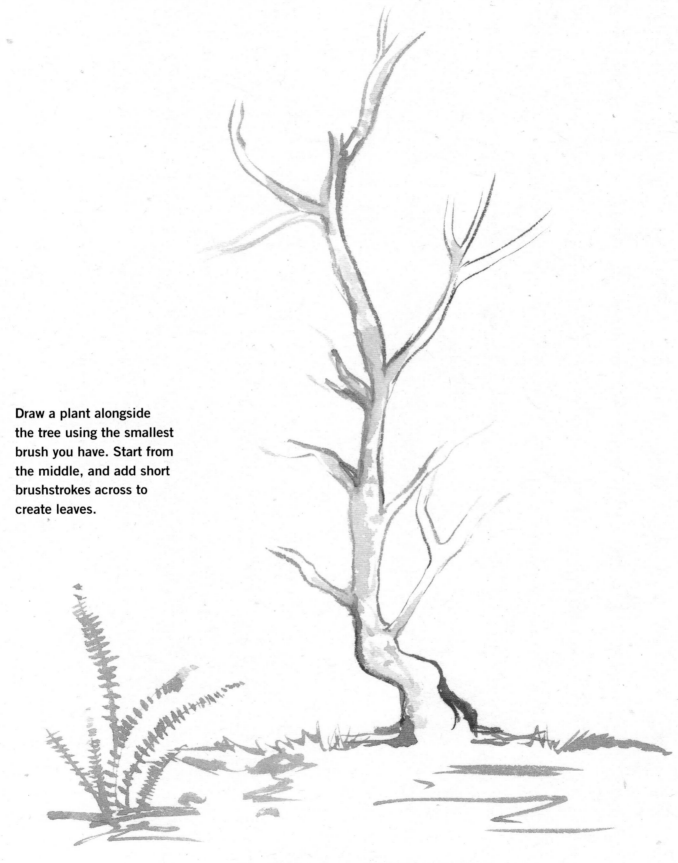

Draw a plant alongside the tree using the smallest brush you have. Start from the middle, and add short brushstrokes across to create leaves.

Establish the ground with few strokes. Leave some a bit spiky to give the sense of grass.

TIP

When creating the tree's texture, wait until the base is dry. Don't overdo it or make it too dark. Leave one side lighter than the other.

Now work on the color and texture of the tree. Using a small brush, make thin and delicate strokes to resemble the bark.

Try painting this tree with black ink!

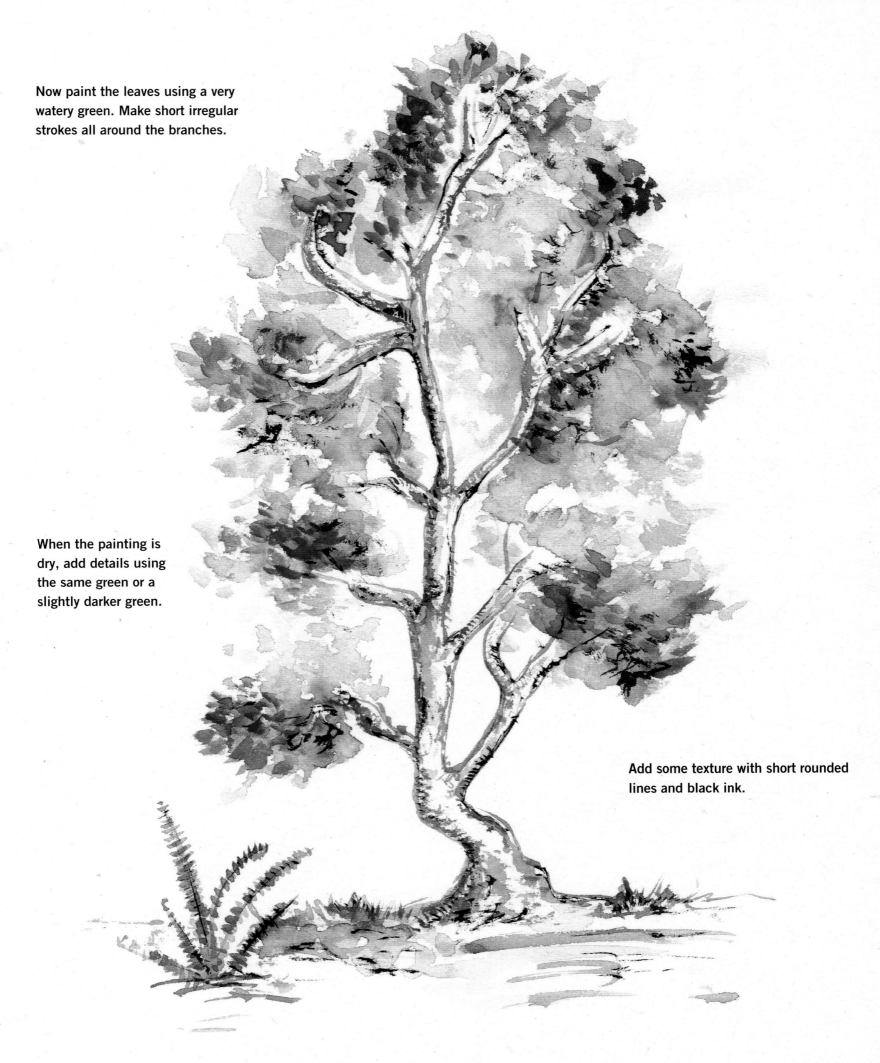

Now paint the leaves using a very watery green. Make short irregular strokes all around the branches.

When the painting is dry, add details using the same green or a slightly darker green.

Add some texture with short rounded lines and black ink.

USING LARGE STROKES

Landscapes are a favorite subject for Chinese brush artists. Use this project to practice your stance and movements. Remember to move your whole arm—not just your wrist—when painting.

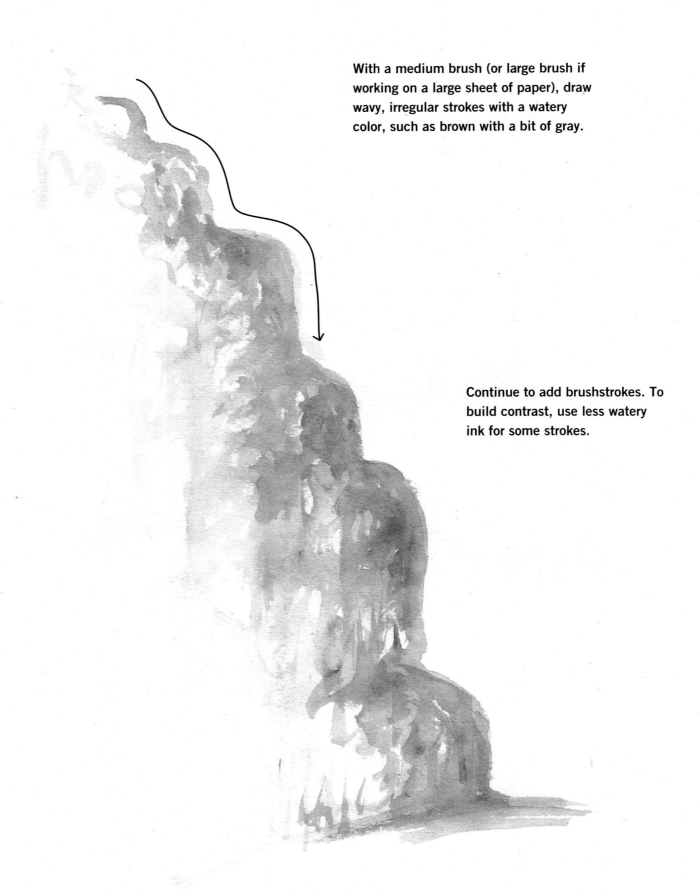

With a medium brush (or large brush if working on a large sheet of paper), draw wavy, irregular strokes with a watery color, such as brown with a bit of gray.

Continue to add brushstrokes. To build contrast, use less watery ink for some strokes.

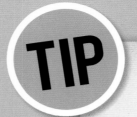

TIP

Build contrast by using a dry brush for the tree. You'll paint with darker, more striking brushstrokes.

Use a dry brush for black ink and a second brush for colored ink.

Paint the tree with short, quick strokes, starting from the top and moving downward.

Paint a long, bold stroke along with additional smaller lines at the bottom to create the effect of the ground.

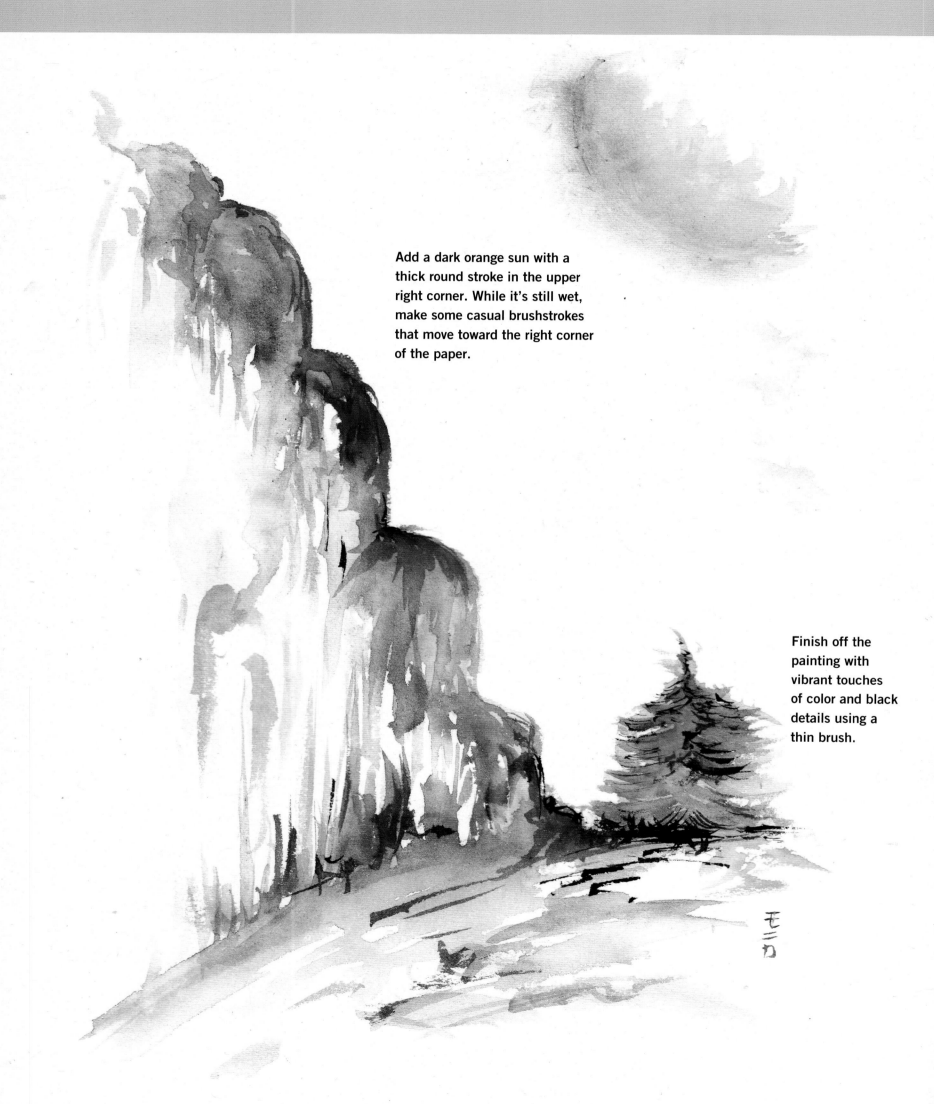

Add a dark orange sun with a thick round stroke in the upper right corner. While it's still wet, make some casual brushstrokes that move toward the right corner of the paper.

Finish off the painting with vibrant touches of color and black details using a thin brush.

Try this landscape painting in black and white.

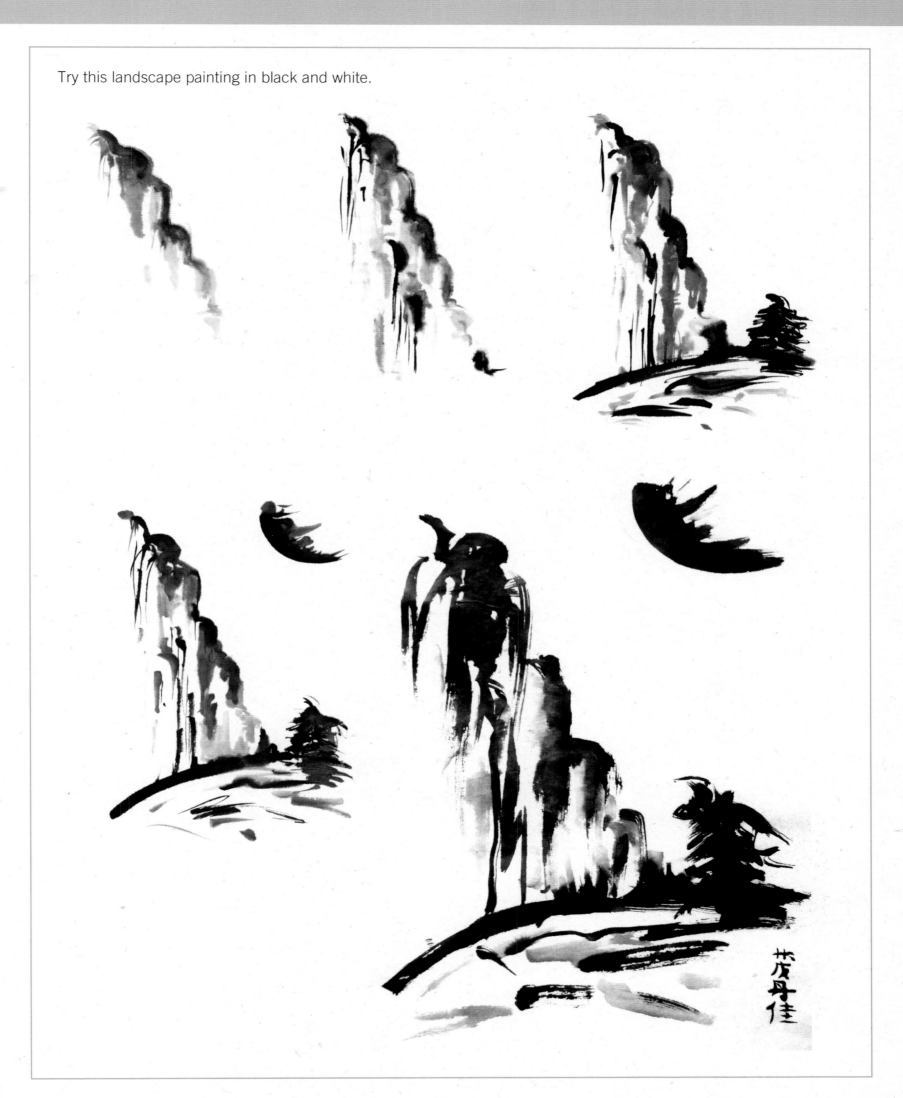

PAINTING WITH NUANCE

When painting the much-loved panda, it's tempting to use bold, black paint on his ears and legs. However, using restraint results in variety and texture. Complete the scene with bamboo and a blue sky.

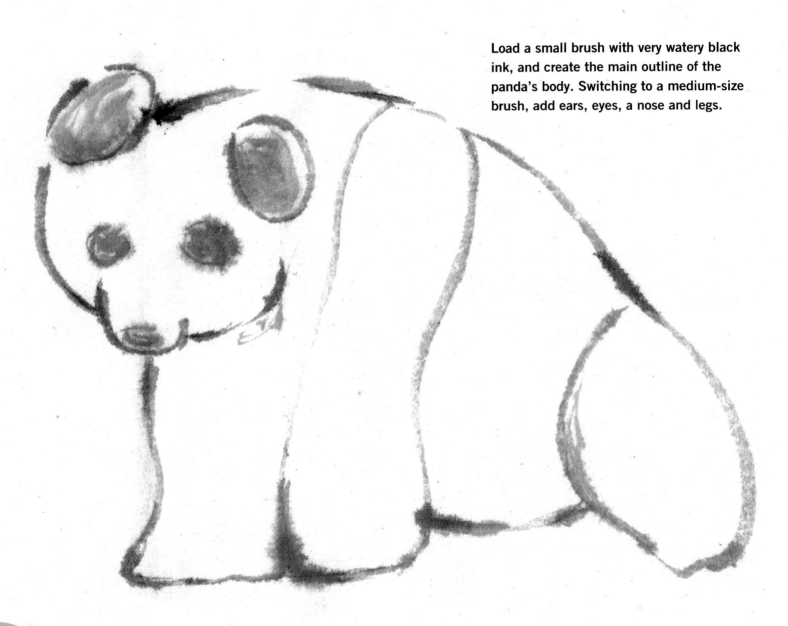

Load a small brush with very watery black ink, and create the main outline of the panda's body. Switching to a medium-size brush, add ears, eyes, a nose and legs.

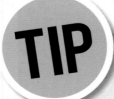

TIP

When dipping the wet brush into the ink, do not saturate the brush. Load only a bit of black at a time. Continually test the brush on scrap paper and remove extra ink if necessary.

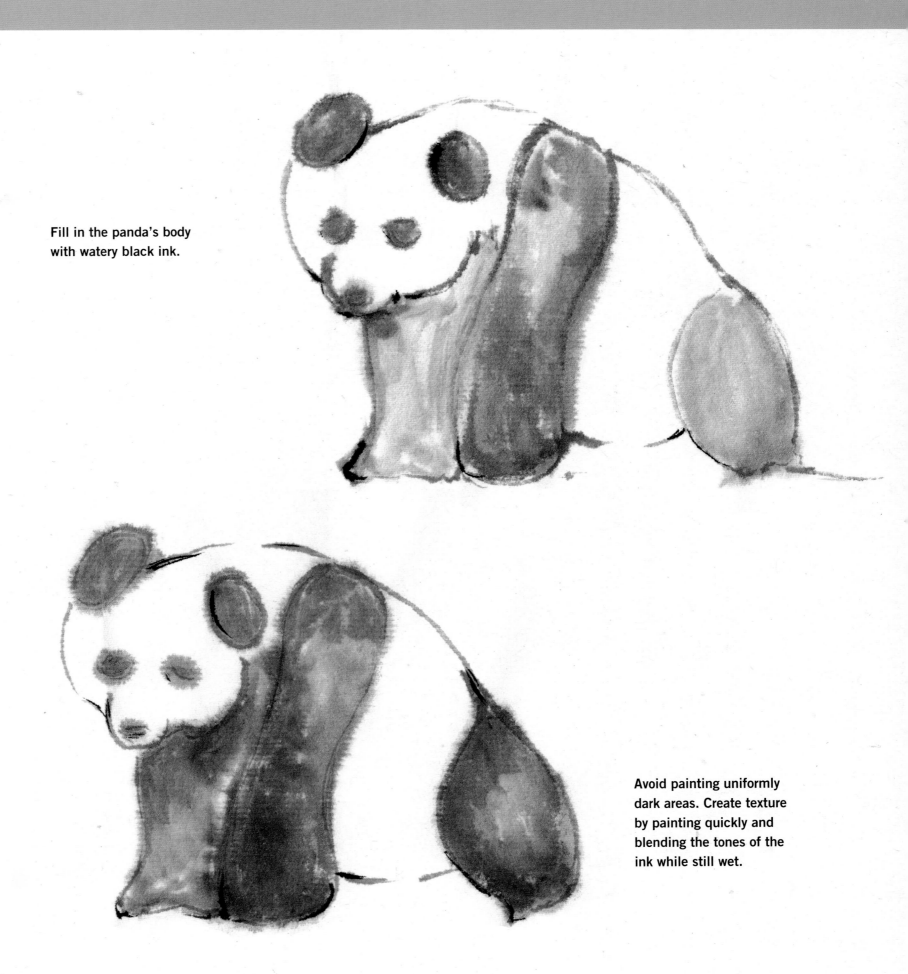

Fill in the panda's body with watery black ink.

Avoid painting uniformly dark areas. Create texture by painting quickly and blending the tones of the ink while still wet.

SPECIAL SUBJECTS

Now paint the grass with green ink, and begin drawing the bamboo.

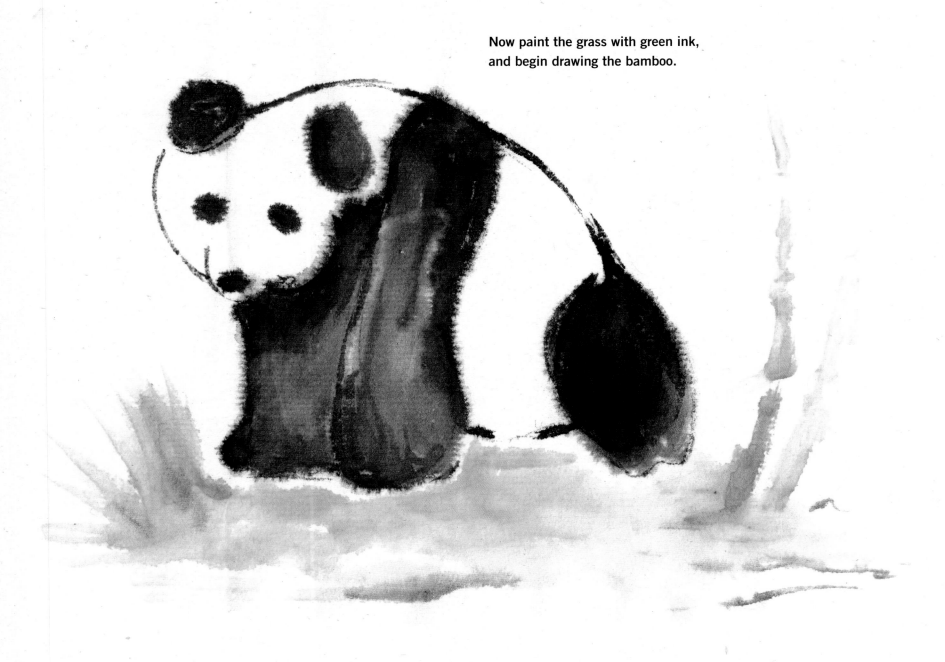

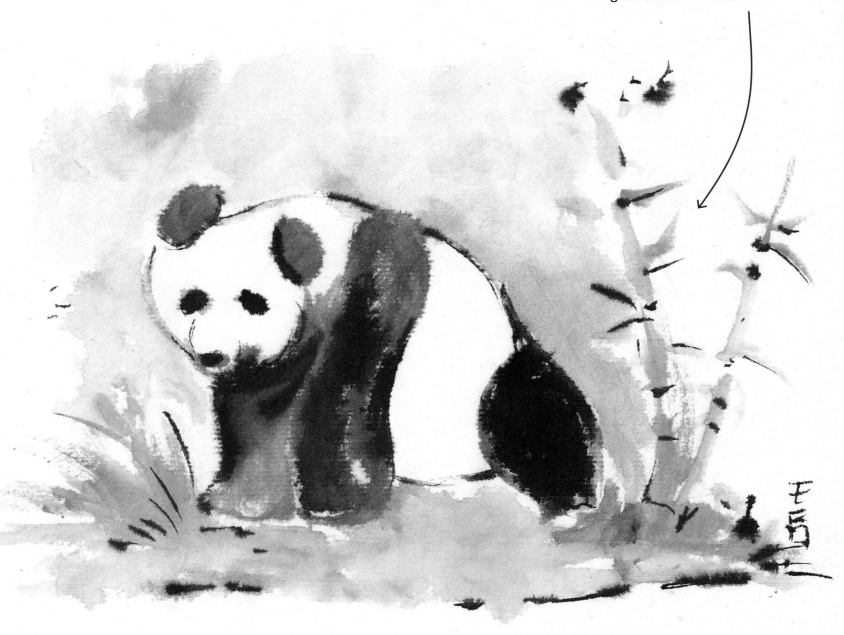

To finish off the painting, darken the panda's eyes with black, and add a few strokes of black to the ground and the bamboo.

Add watery blue to the background, and use green again to add details and blend with brown and black.

ENRICHING DETAIL

The heron symbolizes strength, purity, patience, and longevity. Its graceful and elegant shape is created using only a few tonalities. Create details with black highlights in the birds, as well as on the eye-catching branch nearby.

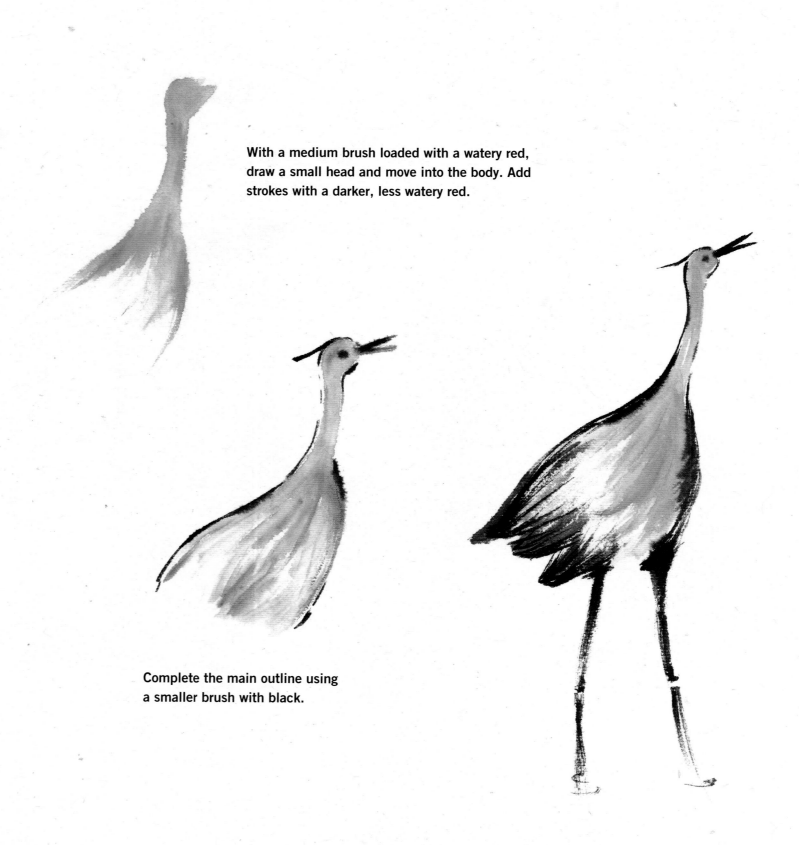

With a medium brush loaded with a watery red, draw a small head and move into the body. Add strokes with a darker, less watery red.

Complete the main outline using a smaller brush with black.

Complete the body with black, adding wings and legs. Add thin strokes to the wings with non-diluted black.

Wait few moments for the red to dry slightly (but not completely)
so the black doesn't create splotches.

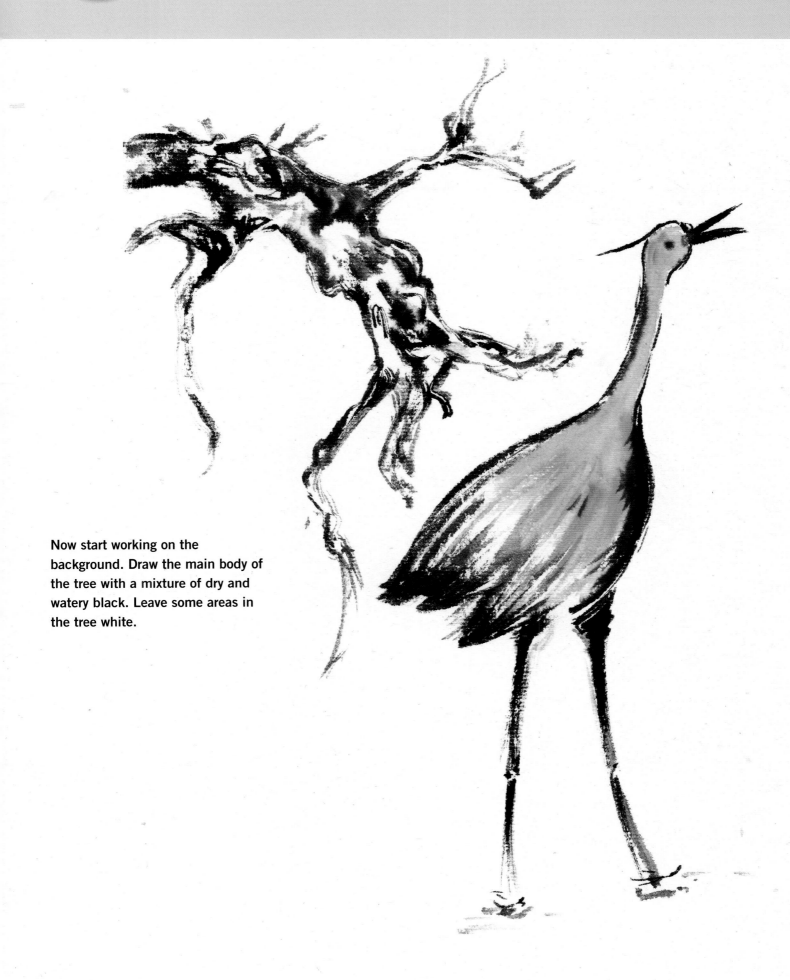

Now start working on the
background. Draw the main body of
the tree with a mixture of dry and
watery black. Leave some areas in
the tree white.

Complete the tree by filling the trunk and branches with some brown and more black and gray.

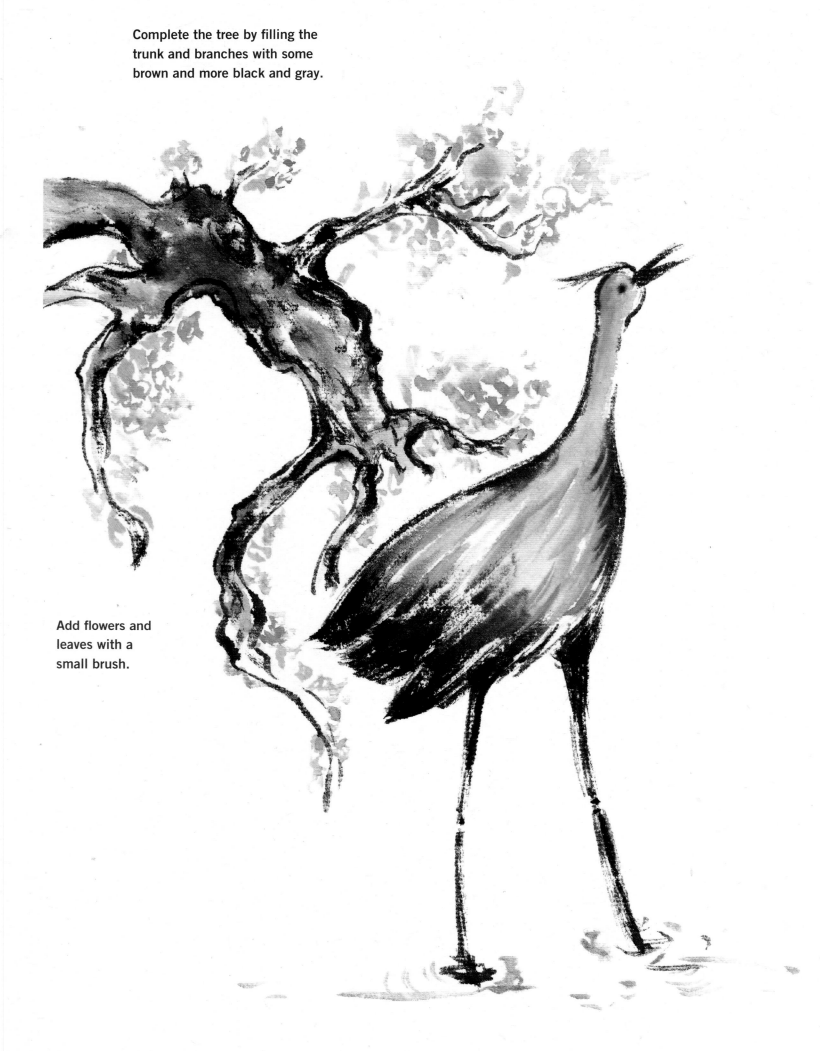

Add flowers and leaves with a small brush.

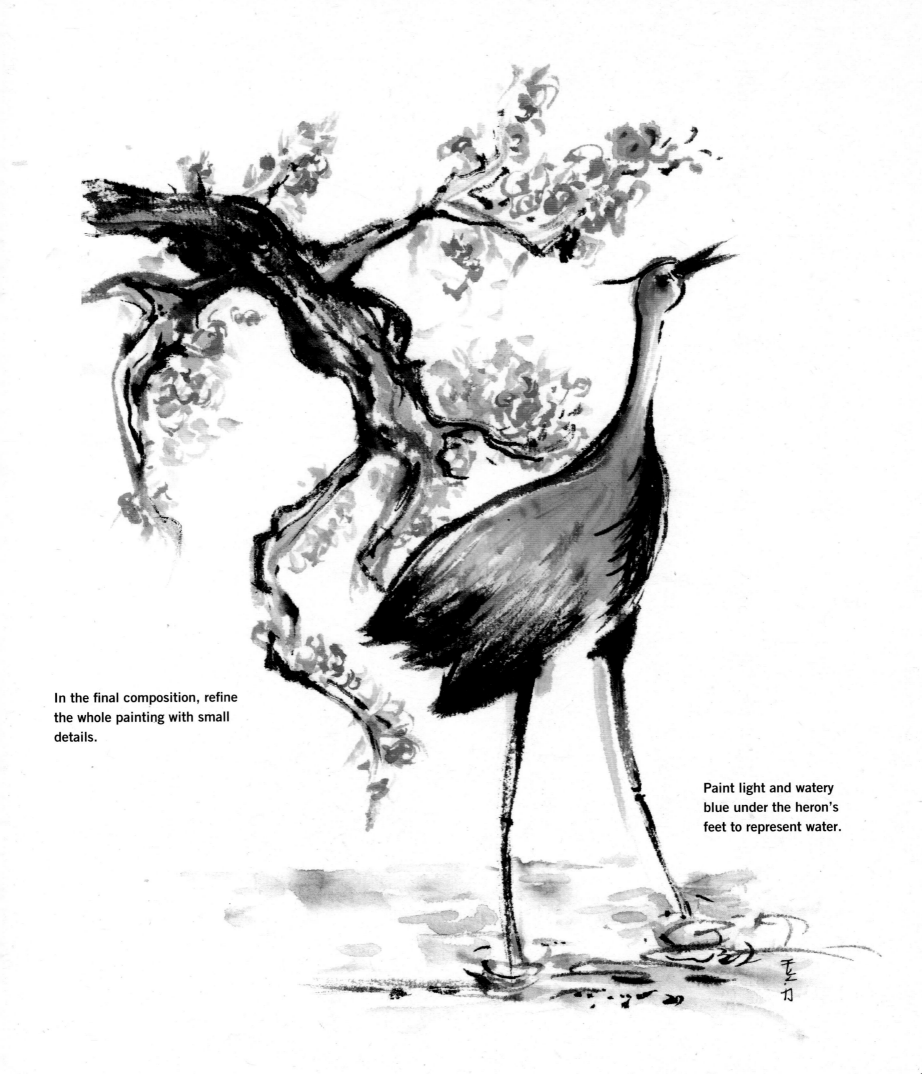

In the final composition, refine the whole painting with small details.

Paint light and watery blue under the heron's feet to represent water.

FOCAL POINT

When painting subjects up close, you can capture the details of a shape of even the smallest animal. In this painting, use black to define the slope of the frog's back and sides.

Load a medium brush with a light, watery brown, and draw the main body, starting from the head.

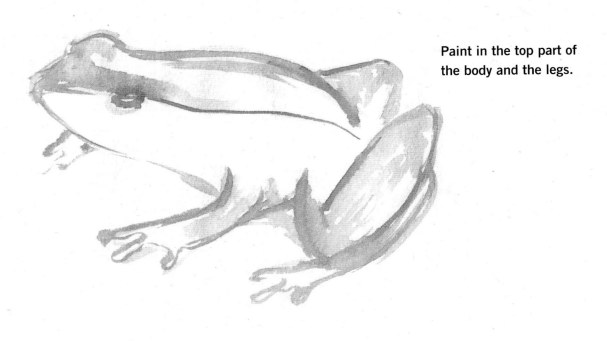

Paint in the top part of the body and the legs.

Continue to build up the shape with color, filling more space with the brown. Leave some areas white.

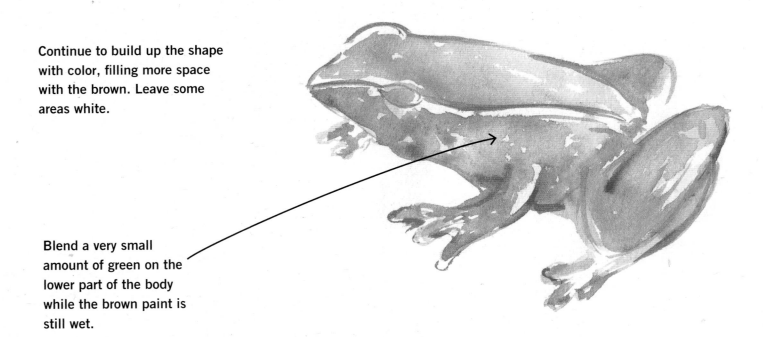

Blend a very small amount of green on the lower part of the body while the brown paint is still wet.

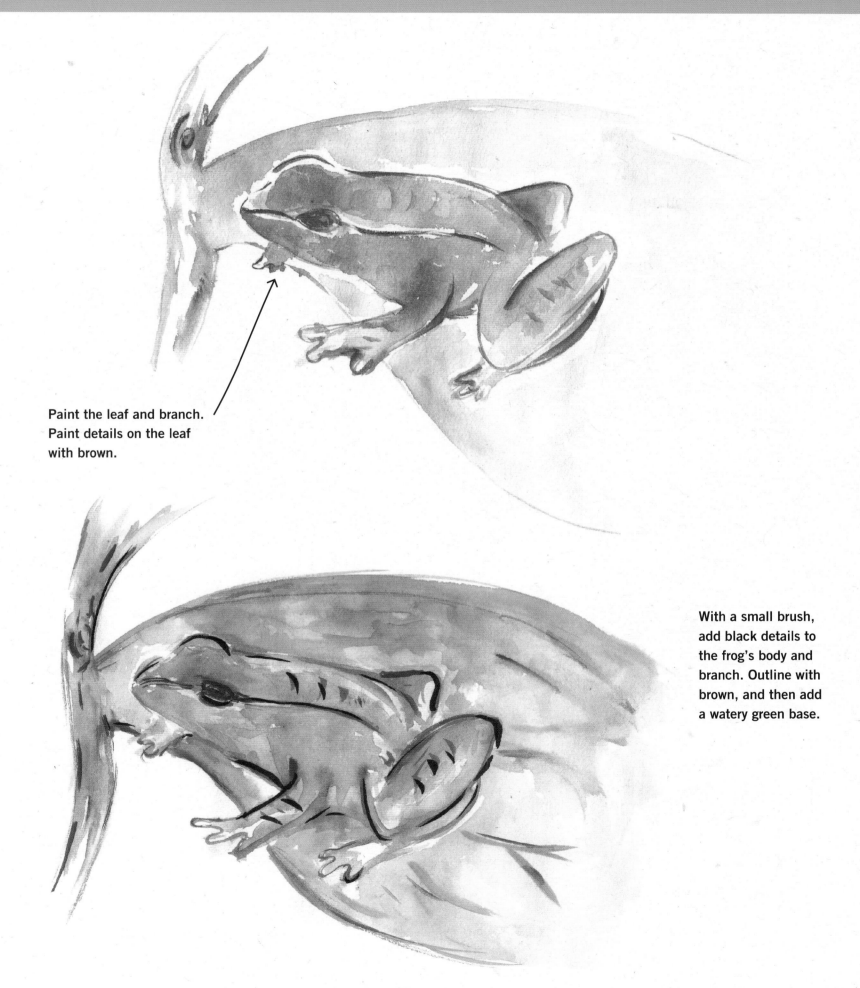

Paint the leaf and branch. Paint details on the leaf with brown.

With a small brush, add black details to the frog's body and branch. Outline with brown, and then add a watery green base.

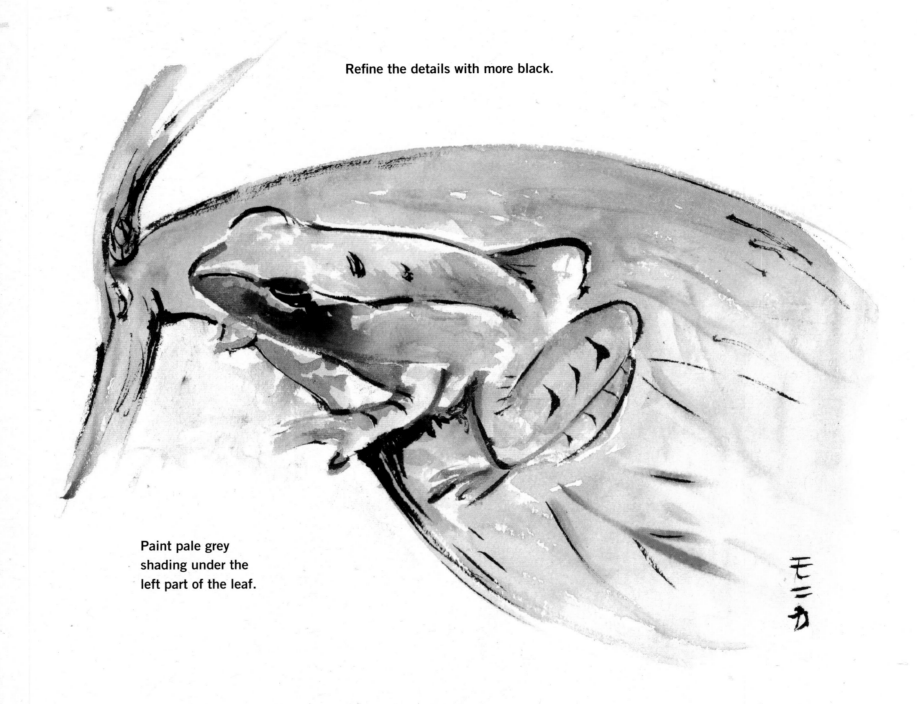

Refine the details with more black.

Paint pale grey shading under the left part of the leaf.